EARTHEN PIGMENTS

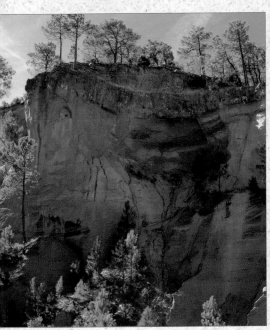
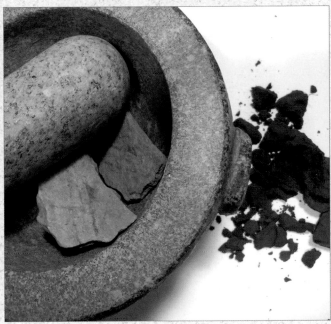

Hand-Gathering & Using Natural Color in Art

Sandy Webster

Schiffer Publishing Ltd

4880 Lower Valley Road • Atglen, PA 19310

EARTHEN PIGMENTS

For Lee

Published by Schiffer Publishing, Ltd.
4880 Lower Valley Road
Atglen, PA 19310
Phone: (610) 593-1777; Fax: (610) 593-2002
E-mail: Info@schifferbooks.com

For the largest selection of fine reference books on this and related subjects, please visit our website at **www.schifferbooks.com.** You may also write for a free catalog.

This book may be purchased from the publisher. Please try your bookstore first.

We are always looking for people to write books on new and related subjects. If you have an idea for a book, please contact us at proposals@schifferbooks.com.

Schiffer Books are available at special discounts for bulk purchases for sales promotions or premiums. Special editions, including personalized covers, corporate imprints, and excerpts can be created in large quantities for special needs. For more information contact the publisher.

Designed by Stephanie Daugherty
Type set in Lithos Pro/Avenir LT Std (OTF)
ISBN: 978-0-7643-4178-6
Printed in China

Unless otherwise noted, all photos and drawings are by the author.

CONTENTS

1

AN INTRODUCTION TO EARTH PIGMENTS

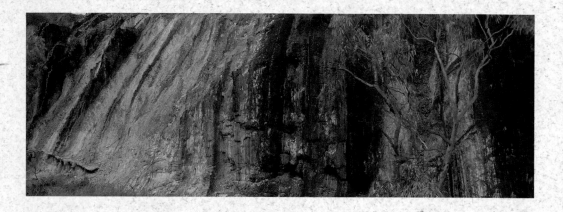

"And these colors showed up in this earth just the way a wrinkle shows in the face of a man or woman."

—Cennino Cennini

THE COLORS CENNINO CENNINI NOTICED WHILE WALKING WITH his father in Tuscany have been the source of mark-making for artists throughout time. Earth pigments, commonly referred to as "ochres," occur naturally on the earth's surface and are quite likely the most permanent of all colors, as they are little affected by time and ever-changing atmospheric conditions.

Natural pigments began being used in early cave and body paintings. In fact, recent discoveries by archaeologists working in the Blombos Cave of South Africa have shown that emerging Homo sapiens were processing earth pigments as early as 100,000 years ago. The use of these pigments continued through history, as evidenced in illustrated Medieval manuscripts, on works of the Renaissance period, and to some degree today with the various paint industries. As science and technology developed, a wider range of colors became available not only to take the place of natural pigments, but to provide an infinite variety of additional colors.

Although earth pigments have been readily available throughout the history of art making, few sources remain for learning how to find and use

Yet there are still artists – many artists – who make their own materials, perhaps out of necessity or through an interest in placing their art practice in a historical context. Some contemporary artists thoroughly enjoy the alchemy of processing pigments and the pleasure of experimenting with tools and methods used by artists long ago. Additionally, there are artists who desire to mark time, place, and memory in their own art work. Nothing does that quite like taking soil from a place where something that truly mattered happened and transforming it into a medium that can make a mark that stimulates recollection and memory. That smudge of pigment on the page can be the physical evidence of an experience or simply a lovely color on the artist's palette; either way the mark is worth pursuing.

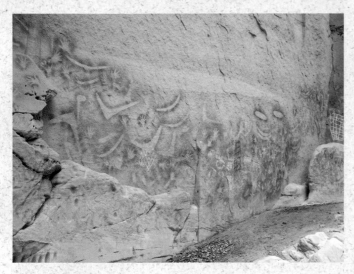

Rock paintings at Carnarvon Gorge National Park Queensland, Australia.

them. Researching articles or out-of-print books on how to find and process pigments into a usable art medium is not an easy undertaking. As for using the pigments, most of us interested in learning more on the subject resort to *The Craftsman's Handbook*, Daniel Thompson's 1933 translation of the classic Cennini book titled *"Il Libro dell'Arte"*.

Exactly what are earth pigments or natural ochres made of? Earth or soil pigments are tiny particles of salts or metallic oxides that absorb some wave lengths of light and reflect others. The reflected wave length is the only one we can see. These pigmented soils contain varying amounts of the mineral iron oxide (Fe_2O_3). This mineral is called

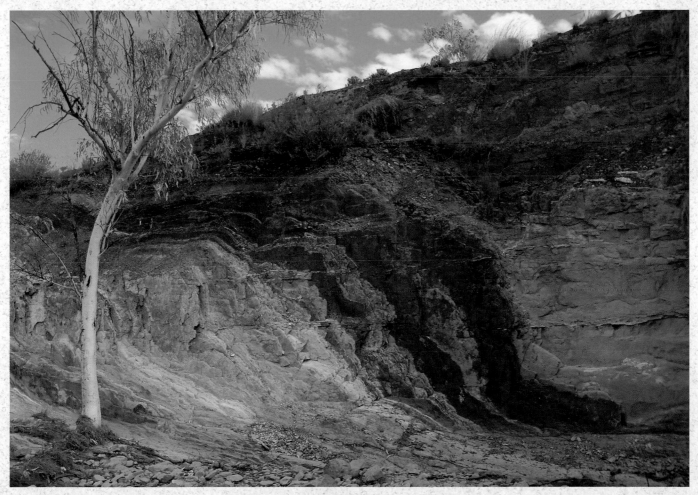

Ochre Pit in the Northern Territory, Australia.

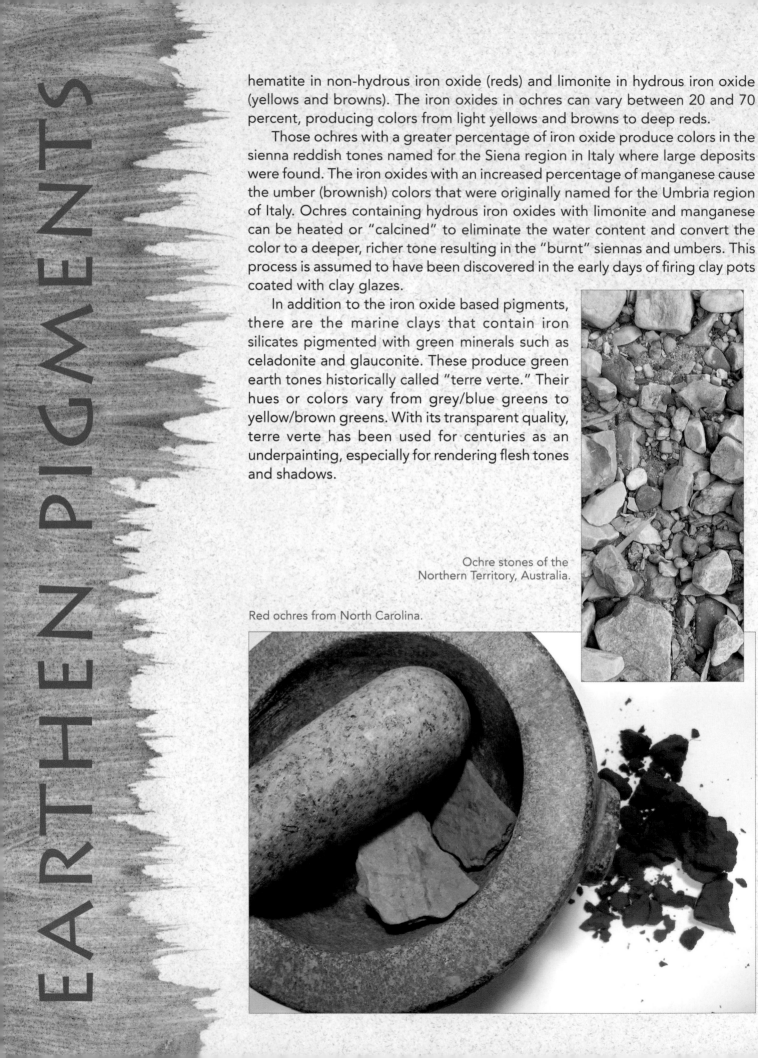

hematite in non-hydrous iron oxide (reds) and limonite in hydrous iron oxide (yellows and browns). The iron oxides in ochres can vary between 20 and 70 percent, producing colors from light yellows and browns to deep reds.

Those ochres with a greater percentage of iron oxide produce colors in the sienna reddish tones named for the Siena region in Italy where large deposits were found. The iron oxides with an increased percentage of manganese cause the umber (brownish) colors that were originally named for the Umbria region of Italy. Ochres containing hydrous iron oxides with limonite and manganese can be heated or "calcined" to eliminate the water content and convert the color to a deeper, richer tone resulting in the "burnt" siennas and umbers. This process is assumed to have been discovered in the early days of firing clay pots coated with clay glazes.

In addition to the iron oxide based pigments, there are the marine clays that contain iron silicates pigmented with green minerals such as celadonite and glauconite. These produce green earth tones historically called "terre verte." Their hues or colors vary from grey/blue greens to yellow/brown greens. With its transparent quality, terre verte has been used for centuries as an underpainting, especially for rendering flesh tones and shadows.

Ochre stones of the Northern Territory, Australia.

Red ochres from North Carolina.

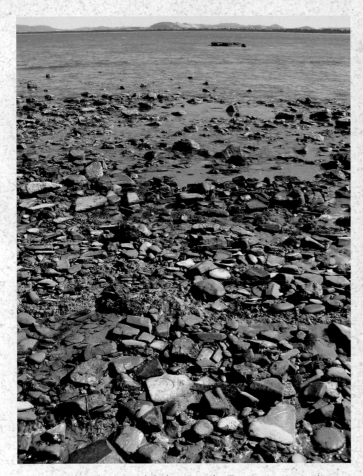

Pigmented rocks at Red Ochre Beach, Tasmania, Australia.

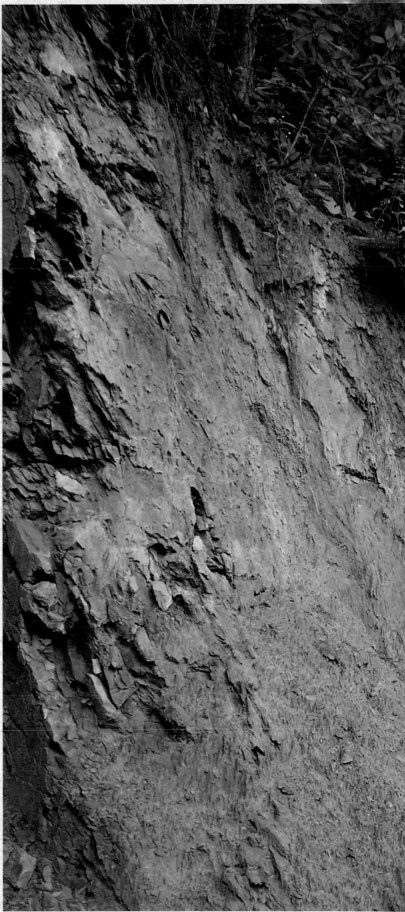

Earth pigments are found in almost all parts of the world. The most desirable locations for commercial mining of natural pigments or ochres have been France (see Ochre Mining in Gargas, France, page 9), Italy, Spain, and Cypress. In the United States deposits of earth pigments have been mined all along the Great Appalachian Valley extending from the east coast of Canada south to the state of Alabama. Deposits of earth pigments are extensive worldwide, but are no longer mined to the degree they once were. Contemporary synthetic pigments are more dependably consistent in color, safety, and accessibility. But for some artists there is a special connection to place, process, and product that is best expressed through the use of natural earth pigments.

For several years I have actively sought out ways to make a mark with soils from the locations that have a particular meaning for me. My home is in western North Carolina, an area filled with clays of many colors: reds, siennas, yellow ochres, and subtle grey greens. I collect these pigments either for their luscious color or because of how their use can record my connection to the place they come from.

Excavation on Carl Green's property Brasstown, North Carolina.

The ochres I have found in other countries seem somehow more precious due to the fact that they are unique physical evidence of my time there. Travels in Australia, New Zealand, Japan, and China have increased my collection of earth pigments and expanded my palette. Australia alone has yielded eighty-four of them over a period of fourteen years and eight visits. I carefully gather, process, document, and bring home each of these pigments. I tuck them all somewhere in my luggage or send them by post with whatever else I find irresistible.

At home in my studio I label my hand-gathered pigments according to location. Then I carefully grind, sift, or levigate them into colors as pure as I can get them, to use in my drawings, paintings, and textiles. The resulting paints allow me to fix "place" upon each piece of artwork and contribute to the narrative of my art.

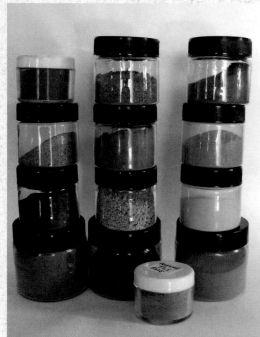

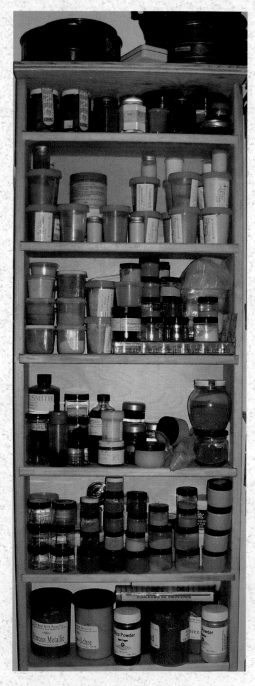

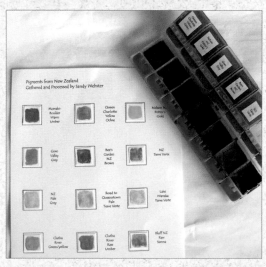

CLOCKWISE FROM TOP LEFT: Jars of processed pigments from France. Pigment shelves in author's studio. Water color set of New Zealand pigments.

Ochre Mining in Gargas, France

The Bruoux Mines began exploiting their rich ochres in the 1840s. An experienced miner would pick the site for excavation along an eroded section of land that exposed great heights of colored ochre. The first miner to go in was chosen for his ambidextrous ability to handle two pick axes simultaneously as he sat on his heels and made an arch as high and wide as he could reach with arms extended. This miner was considered the most important and paid accordingly.

Next, two additional miners would sit in the same space side by side. One had to be left handed and the other right. They would use their pick axes to dig down as far as they could reach on each side of where they sat. Left-handed miners were harder to come by, so like the first miners, were paid more than the right-handed miner.

When the miners dug as far as they could from this position, they vacated the section they were sitting on so that black powder could be centered into the block and charged, breaking the mass into several large sections of ochre. These were then removed and taken off for further processing.

The miners would continue to work this way downward and deeper into the mines creating large cathedral-like arches into the earth. The Bruoux mines of Gargas are up to eighteen meters high and four meters wide.

Additional arches at right angles to the main entrance would be dug out the same way. Because

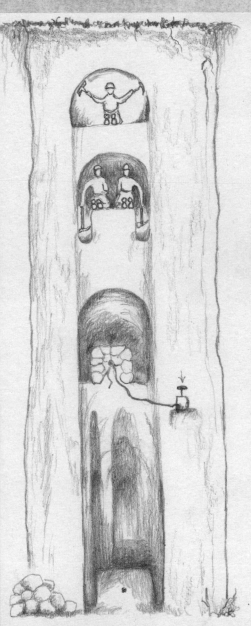

Drawing of mining in Gargas, France.

of the tremendous amount of sand (80% sand to 20% ochre) and the continuously increasing dampness, the miners would listen at the walls to make sure they heard no other miners coming closer than six meters from where they were tunneling. To aid in evaporating the water, miners deliberately scored the walls to increase its exposed surface.

The ochres throughout the region of Roussillon to Rustrel France require considerable washing and flushing of sand before the raw ochre is left to dry under the sun in large flat beds. Then it is cut into bricks to be taken to the plant for the last stages of processing and packaging.

The Bruoux mines stayed productive until World War I, when the miners were recruited and the female labor force took over. Despite their efforts to stay in business, the mines close shortly thereafter. From the beginning of the Bruoux mines history, its production rose from 48 cubic meters in 1887 to 2,185 cubic meters in 1911. The advent of artificial oxides and the market crash of 1929 brought on the decline of ochre mining.

Some of the galleries of the Bruoux mines re-opened in the 1950s as mushroom beds and continued being used for this industry until the close of the twentieth century. Floods closed the mines until sections were cleared and opened for guided tours starting in 2009.

2

Gathering Earth Pigments

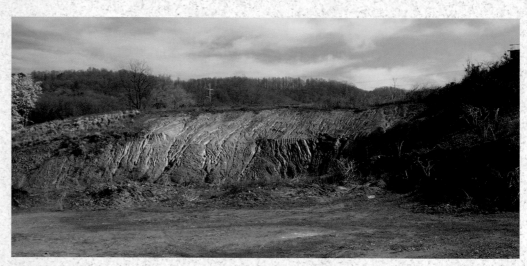

Highway 64 near Brasstown, North Carolina.

HUNTING AND GATHERING PIGMENTS IS AN EXCITING PART IN the process of making artists' mediums. I am always watching out for new colors or collecting soils from places that need to be documented beyond just words on a page. The landscape is full of possibilities for the paint box, and it seems I never tire of adding to it.

Basic Equipment Needed in the Field:

- Trowel
- Hammer
- Spoon
- Several plastic bags of various sizes for holding different soils
- Sheets of paper to drop into bags after recording location and color
- Permanent markers
- Sketch/notebook
- Boots
- Gloves

Excavation sites along roads are the easiest places to find and collect soils. When gathering at a new construction site, gather as much as you can on your first visit. The site will change, and once equipment is brought in, it will no longer be a desirable location.

From experience, I believe it is best to gather pigments early in the day. Go when there is enough light to see color variations but while there is little traffic along the roads. If confronted by the property owner or interested passersby, explain what you are doing and why. I have found that those who stop find it very interesting and even offer assistance. But to avoid unwanted interruptions I try to go early in the day.

When carrying empty bags out into the landscape, keep in mind the distance back to the car. It is easy to get carried away when spotting a particularly good color and fill bags so that they are too heavy to carry comfortably. I place each colored soil I gather in a plastic bag. With a permanent marker I write the name for each soil directly on the bag or on a paper inside the bag. I always begin with the location first – for instance, Rivercane Road Gold Ochre. Sometimes I will make a drawing of the location in my sketchbook and note where I found each color at that site.

Back home, I empty each bag onto a large separate sheet of paper with the name of the color written in a corner. I leave the soils to dry in the sun but out of the wind. Once they are completely dry, I place the soils in sealable plastic bags, label them again, and store them until I'm ready to process further.

3

PROCESSING EARTH PIGMENTS

THERE ARE TWO WAYS TO PROCESS THE PIGMENT OUT OF YOUR hand-gathered soils. Each method will eliminate the unwanted organic matter as well as the heavy sand and gravel often found in soil.

Dry Sifting Method

Equipment and materials needed in the studio for sifting dry pigments

- Dried soils
- Dust mask
- Latex gloves
- Heavy-duty mortar and pestle (a twelve pound granite one works well)
- One sieve or sifter with approximately a 35-count per inch mesh screen
- A second sieve or sifter with approximately a 100-count per inch mesh screen
- Large (ledger-sized) sheets of white paper
- Distilled water
- Metal scraper or spatula
- Glass muller (available at art supply stores or online)
- Sheet of tempered glass not less than 18 inches across and ¼ inch thick (a glass shop can cut and bevel the edges or you can purchase a small finished glass table top)
- White cloth or paper to place under the glass sheet to enable seeing the pigment colors

A note on the screens:

Professional sieves are available through scientific laboratory equipment suppliers. When teaching workshops, I use several sets of screens that I made from five and eight inch embroidery hoops holding brass screens. The larger grid screen is in the larger hoop and the smaller grid in the smaller one. When turned bottom side up the hoops have just enough edge to contain the unscreened soil while it is shaken back and forth.

Directions

Put on your dust mask and gloves. Place not more than one-half cup of the dried soil into the mortar. With the pestle crush it to a powdery consistency. Write the name you gave the pigment in the corner of a large piece of white paper. Place the bigger screen over the paper and carefully pour the crushed soil into it. Gently shake the screen back and forth over the paper until all the soil has been sifted through. Discard any organic matter such as leaves, grasses, barks, and the sand and small stones that are left on the screen.

Carefully bending the paper to form a spout, pour the sifted soil into the small screen placed directly on the glass. Gently shake this screen back and forth to filter out all but the colored pigment, which should pass through the screen onto the glass. Avoid the temptation to push the soils through the screens. There are times when a very fine clay-based soil can clog the screens, especially the smaller one. I have found using a stencil brush with stiff bristles helps the pigment to pass through easily.

Note: You might save anything left in this smaller screen to use as texture in your work. Bag and label it with its name and process, *e.g.* "Rivercane Road Gold Ochre – Sifted Once," or simply discard it.

Once the sifted pigment is on the glass, take a metal scraper or spatula and shape it into a small elongated mound. Gouge a depression along the spine of the mound. Slowly fill this indentation with distilled water. The pigment will absorb the water most of the time. But if the water runs off or away from the pigment, add about a teaspoon of denatured alcohol to the pigment. The alcohol makes the absorption of water possible and then quickly evaporates.

Add enough water to make a paste the consistency of thick sour cream. Place the glass muller directly onto the wet pigment and move it in a slow circular motion, grinding the pigment into smaller and smaller particles between the two glass surfaces. Stop every so often to scrape the pigment back into a pile and then mull it all again.

Some pigments will naturally be more "gritty" than others, but with enough mulling a smooth paste is usually possible. Label a small watertight container (recycled medicine and cosmetics containers work well) with the name of the pigment. Use the metal scraper or spatula to transfer the wet pigment into the container.

Process all remaining soil the same way. When all of the color is in the container, cover it with distilled water and cap it. This insures a dampened pigment when you are ready to turn it into a usable paint with a binder such as gum Arabic. There will also be times when you want to keep your pigments in the dry sifted form to be used in making crayons, pastels or other mediums where a dry pigment is preferred. Remember to wear your dust mask when handling dry pigment powders.

Finally clean and dry the mortar and pestle, and brush out any remaining particles left in the screens before processing the next color.

A note on safety:

Do not use a mortar and pestle from the kitchen; purchase one for studio use only. If you are processing quite a few soils at one time, use a dust mask to prevent inhaling excessive amounts of airborne particles. Protective latex gloves are also recommended.

Levigation or Wet Method

In addition to the dry screening method there is the process of levigation — suspending soil particles in water in order to use their different specific gravities to separate the pigment from sand and other matter. Although it takes more time, levigation often produces a finer, purer pigment.

Equipment needed for levigation of soils

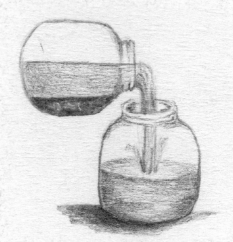

• Two or three jars
• Rubber spatula
• Scraper
• Glass muller
• Glass sheet

Place wet or dry soil into a jar of water. The ratio should be about one part soil to six parts water. Swish this around quickly and pour off any organic matter that floats to the surface. Fill the jar with water again, stir, and let the contents sit for a few seconds. Carefully pour only the clouded colored liquid into the second jar. Label a paper with the name of the pigment and keep it under the jar.

Anything left in the bottom of the first jar is likely to be sand and stone. Discard it and rinse out the jar.

The colored pigment is suspended in the liquid of the second jar. Some pigments will settle quickly, but others can take a few days depending on the specific gravity of the pigment particles. After the water clears and the color has settled to the bottom, slowly pour off the water. If you notice a layer of grit at the bottom of this second levigation, before emptying the jar repeat the first levigation: give it a gentle swirl and pour the colored water into a third jar leaving the grit behind. Repeat the settling process as described above.

Because of different specific gravity of a second pigment, it is possible to get two different layers of usable color in the bottom of the jar. Carefully remove each with a rubber spatula. Don't forget to name the second color – e.g. Rivercane Road Gold Ochre – Dark.

Now process the pigment more finely with the muller and glass sheet. Add some distilled water if necessary to achieve the consistency of sour cream and label each pigment. Store them in small containers.

A note on the water in the pigment:

If you want a pigment that has not potentially been affected by the minerals in the levigation water, use distilled water for levigation or let the wet pigment dry completely and pulverize it in the mortar and pestle. Empty the mortar directly onto the glass sheet and, as in the sifting method, use distilled water in mulling.

EARTHEN PIGMENTS

4
GATHERING AND PROCESSING EARTH PIGMENTS WHILE TRAVELING

IT IS ALMOST IMPOSSIBLE TO PROCESS PIGMENTS USING THE METHODS above while traveling. So in order to make the packing and processing simple, I pack small plastic bags, a metal spoon, a very small three-inch-diameter mortar and pestle, and screens for sifting. One of the screens is a larger-mesh, cup-shaped one designed for filtering tea leaves, and the other I made myself using a fine mesh screening fitted onto an embroidery hoop. With these few tools I can gather, label, and process a fine enough pigment for use in the field or to simply save for later.

If possible, heat dry pigments in a microwave to kill any remaining bacteria before storing in its labeled bag.

Never remove soils from sites where it is prohibited or where permission is in question. When traveling in a country where you are dependent on others to get around, it is good to have a driver willing to stop for you to collect soils along the way. I have been fortunate to have many drivers who find the process of gathering pigments fascinating, and each has been very helpful in adding to my collections. And finally, be prepared to show your driver where you have used the pigment in your sketchbook. After showing my sketchbook to our guide in China, he was very happy to help me collect clay near the site of the terra cotta warriors in Xian – a lovely pale umber.

Ways to use the gathered pigments while traveling

In the field or back at the hotel, you can make a watercolor by taking a small amount of the pigment, some water, and a touch of honey, which has been used as a binder throughout the history of painting. Without a binder of some kind the pigment will simply brush off the page when dry. Honey not only acts as a binder but as a humectant that aids in the even dispersion of pigment in watercolors and helps the color to flow evenly onto the paper. Traveling with honey between countries is prohibited, but small packets of honey are often readily available. The usual proportions are eight parts wet pigment that is thick and creamy to one part honey if you want to make up a small pool of color in a bottle cap that will harden within a day or so. With this binder the pigment is now a watercolor that can be used in sketchbooks while on location. Once, with no honey available at an outback campsite, I substituted strawberry jam to make a thin "stamping ink" which enabled me to record quickly the shapes of leaves in my sketchbook.

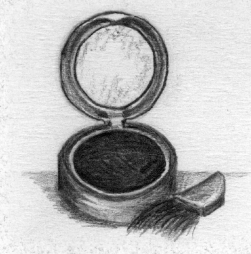

An alternative method of preserving your pigments while traveling is by combining a mixture of about three parts dampened pigment with one part flour — enough to make a thick paste. Shape the paste into a flattened ball for bringing home in the paint box. This "cake" works more like a gouache than a watercolor as it now has the opacity of flour and water (ingredients for wheat paste) to act as the binder. I travel with an empty mint tin to house six of these gouache "cakes." Once home, levigation will remove the flour and return the pigment to a more desirable condition for making various art mediums.

Another way to make and store one of these watercolors or gouaches while traveling is by using the empty compacts from cosmetics, such as face powder and blusher. Simply fill the cavity with a watercolor made of honey and water with pigment or wet pigment and flour and let it dry completely. The large soft cosmetic brushes make wonderful wide strokes of color as backgrounds on journal pages leaving plenty of room for additional drawings and writings.

Other ways to record pigments in the field

The most obvious technique for recording a pigment is to transfer it directly by rubbing the soil on a page in your sketchbook. Without a binder, this will wear off quite easily, but if the pages are handled carefully, a thin solution of honey water can be brushed over the painted area later to keep the color fixed on the page.

My favorite way for direct transfer is to make shifu threads (see page 18). Shifu is a Japanese cloth made by weaving paper that has been dampened, cut, and spun into long threads. For traveling, pack several small sheets of strong fibered papers that measure approximately six inches square in with your art supplies. I use a Thai kozo paper for its strength and durability under the stress of how it will be used to record "place."

Gently rub these sheets against soils, rocks, and barks — anything that will transfer some of its color — and carefully place them in your backpack. You will process these back at the campsite or hotel.

Directions for making shifu threads

Fold each sheet in half, and then bring each end away from that mountain to just past that first fold by about one quarter inch, and fold it in place. From the end the paper will look much like a "W" with the center mountain fold slightly lower than the sides.

Next press the folded paper flat down and cut from the double folds at the bottom through four thicknesses just to past the inside fold. Do not cut through to the outside ends of the sheet. Make a continuous line of slits, spacing the cuts just slightly less than one quarter inch apart.

Open the sheet and notice that it is still intact, yet slit from one side to the other.

Carefully dampen two paper towels and place the open sheet of Thai kozo between them to dampen thoroughly. It will be at its weakest point when damp, so be careful not to get it too wet. If it is, then shake gently to help dry it out a bit. Gather it gently up along one side at the ends of the slits and place it lengthwise on a surface that has a bit of "tooth" to roll the paper strips back and forth with little pressure. Pick it up, shake out the strands to separate them again and repeat the process increasing the pressure each time. When the separate strands have begun to look more like threads than flat strips of paper it is time to make the long continuous thread.

Once the paper has been laid flat and the strands separated from one another, start the tearing at one end. You will tear the entire piece so that it will look like a continuous zigzag of thin, loosely wrinkled paper thread.

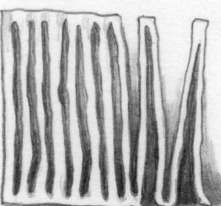

Now gently gather the thread off to the right side and grasp its end with your left thumb and forefinger. With your right thumb and forefinger holding the thread about two inches away, gently spin the paper thread tightly away from you. Grasp the spun section tightly with your left thumb and forefinger so as to keep it from coming un-spun as you continue moving along the length of the thread an inch or two at time, passing it into the left hand. (*Of course this process would be the reverse if you are left-handed, with the finished spun thread coming out below your right hand instead of the left*). It may be necessary to re-dampen the paper as you go along as it must be kept damp to hold a tight twist.

When the thread has been completely spun, wrap it loosely around four fingers of one hand, using the last six inches or so to wrap around this bundle after it has been removed from your fingers. Label this small bundle of thread with the name of the pigment and set aside.

Continue with each of the sheets until you have an assortment of threads in bundles that represent the places they came from. These threads can be used in many ways: for weaving, wrapping, stitching or simply tying small objects or mementoes.

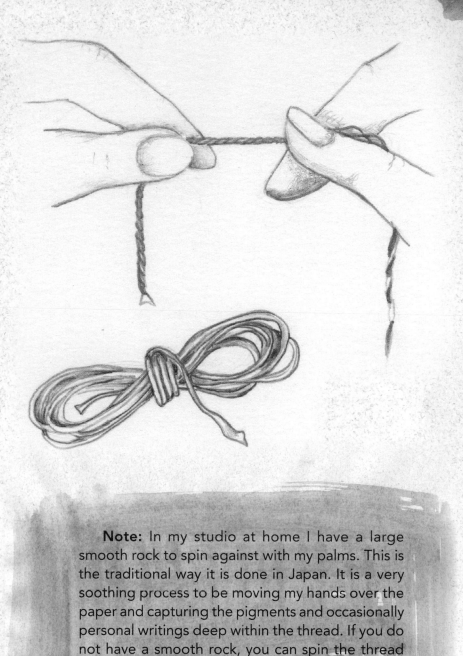

Note: In my studio at home I have a large smooth rock to spin against with my palms. This is the traditional way it is done in Japan. It is a very soothing process to be moving my hands over the paper and capturing the pigments and occasionally personal writings deep within the thread. If you do not have a smooth rock, you can spin the thread against a blue-jean clad leg, upholstered furniture, or any surface with enough texture to trap and spin the paper.

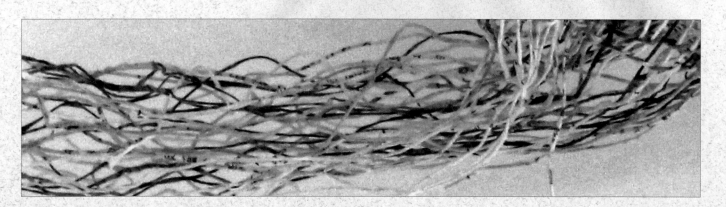

5

SOME EXAMPLES OF HOW I HAVE USED EARTH PIGMENTS

ALL ARTISTS HAVE A SPECIFIC MEDIUM THAT THEY PREFER TO use in their work. In this chapter I will show some of the ways I have used earth pigment. In my studio, I have tried many ways to create workable artist mediums from hand gathered pigments, some more successfully than others. Sharing earth pigments with artists who work in completely different art forms, such as papermaking and ceramics, expanded the possibilities even further.

My preferred choices when working two-dimensionally are graphite, printmaking, and ink, followed closely by watercolor, gouache, and egg tempera. For sculptural works, such as books and boxes, I want more of a textural quality to the medium – something that feels interesting and inviting to the hand. And finally, making marks of place on cloth for use in clothing, quilts, and collage conveys a particular meaning of connection that only worn and softly colored cloth can. Some examples follow.

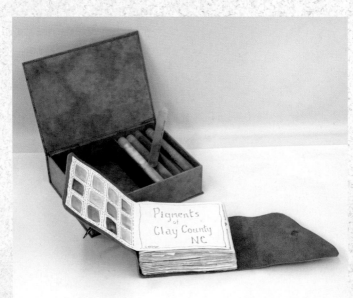

Note: Recipes for the mediums used in this chapter appear in Chapter 6.

This book was made in my studio after several collecting trips near my home in Clay County, North Carolina. I wanted not to waste any paper that was folded down

Photo by Phil Diehn.

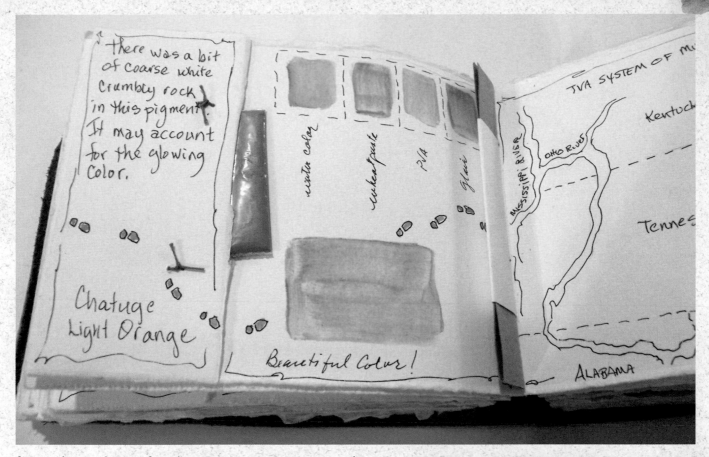

there was a bit of coarse white crumbly rock in this pigment. It may account for the glowing color.

Chatuge Light Orange

water color

wheat paste

PVA

Glair

Beautiful Color!

TVA SYSTEM OF M...

Kentuck...

MISSISSIPPI RIVER

OHIO RIVER

Tennes...

ALABAMA

from a large sheet of Arches Cover paper, so several pages have a folded in front section that houses a plastic bag of the hand-gathered pigment after it was sifted as finely as I could get it. I drew in the locations where the pigment was gathered and painted in samples of different binders used with each pigment. I also added directions on how the pigments could be processed and used. At the end I included instructions on how to make the book. When the book was completely filled with pigments and text and a leather cover made, I housed it with long, sampling test tubes of each of the actual soils as it was gathered together in a box I made to suggest the landscape colors of home.

It has the look of an artist's scientific approach to a collection of "place" and was great fun in the making.

(At right) This is a small watercolor of all the colors I found on Carl Green's property where our cars are inspected annually and where I have been invited to come back and get all the "dirt" I want. A detail of my favorite section is on the right.

EARTHEN PIGMENTS

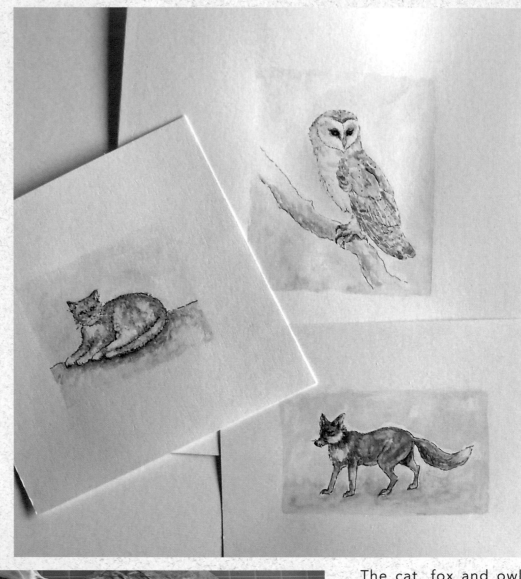

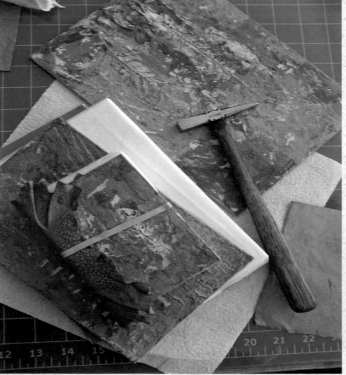

The cat, fox and owl have all been colored with gouache I made from local pigments and accented with a brown-inked pen. Each approximately 5" x 5", they are reminiscent of children's book illustrations or journal entries.

These book covers *(left)* have been colored with locally gathered natural pigments added to white acrylic paint. The mixture was layered over leaves that had been glued to the cover boards. Finally the books were finished with cold waxes made with the same pigments.

This wood panel *(below)* is 15" x 12" x 1" and was drawn into with a non-pigmented casein and wheat paste mixture using a small squeeze bottle. Graphite drawings, gouge marks and pigmented wax crayons complete the design. I then sanded into it before adding a finish of non-pigmented cold wax.

Photo by Phil Diehn.

This is a Coptic-bound, blank journal that I made using recycled card board cracker boxes glued together for the cover board. The front cover was then painted with gesso and textured with a thick casein paint colored with natural pigments. The back cover and edges of the front were covered with a matching lokta paper.

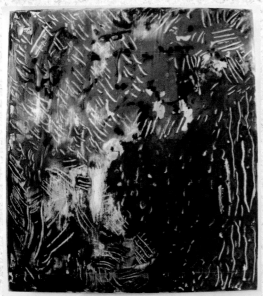

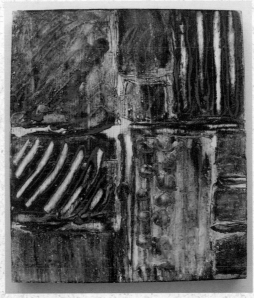

These wood panels *(left)* are 15" x 12" x 1" each and textured with pigment colored casein paste made of non-fat dry milk and wheat flour paste. Each was then gouged, sanded and finally waxed with pigmented cold waxes and buffed to a satin finish.

EARTHEN PIGMENTS

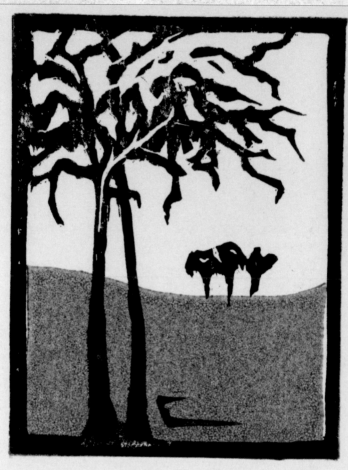

This is a 5" x 7" two stage linoleum block print using a natural pigment ink for the background landscape and purchased relief ink for the black image. The considerable grit in this particular hand-gathered pigment made it a poor choice for the more detailed image, but perfect for the landscape feel of outback Australia.

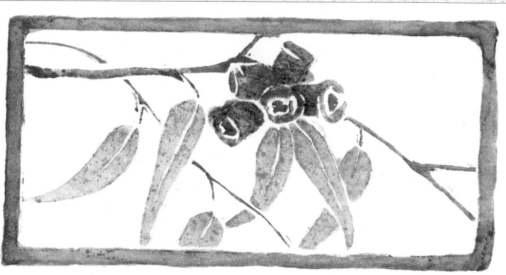

While studying white line printmaking and its history I found the process to be the perfect place for bringing natural pigments into my own relief prints. Here I could use my precious watercolors in a deliberate way to color hand-carved images of the places where I gathered the pigments. This is a white line print of a eucalyptus branch of leaves and gum nuts that I photographed in Australia. All the colors used in the print are from watercolors I made using the pigments I gathered there.

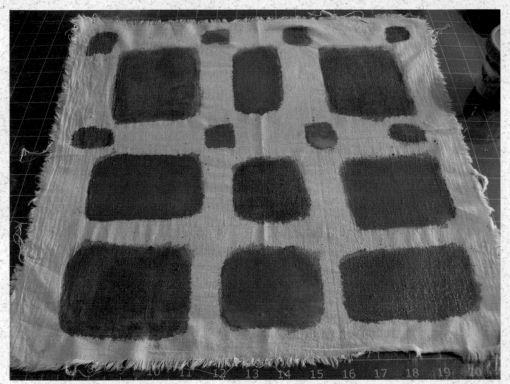

These are photographs of the cloth being colored with pigments in the studio and then the finished product, which is simply cloth waiting to be stitched onto another textile or collaged into a piece of artwork.

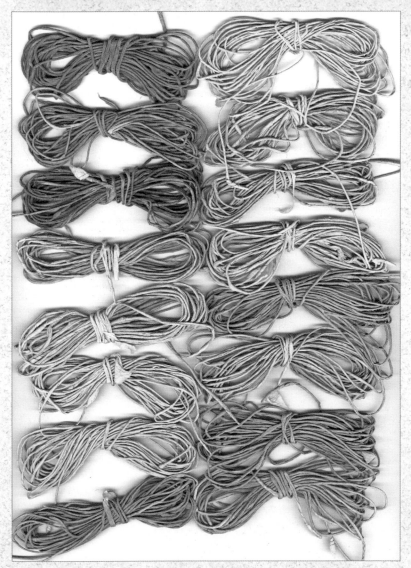

(Left) These are all the shifu threads that have each been made from a six inch square of Thai kozo paper. After coloring each of the pieces of paper with the pigments I have collected by my home, I spun them into these threads to be woven into a book. (see pages 18 – 19).

6

RECIPES FOR MAKING A VARIETY OF ARTISTS' MEDIUMS

NOTE: THE FOLLOWING RECIPES AND INSTRUCTIONS ARE FOR how I have used hand-gathered pigments with binders for my own artworks. There is much written by other artists, historians, and teachers on additional methods that will give similar results. Proportions may vary to insure more or less intensity in color as well as the desired amount of binding materials. This is simply a place to start. If you are unfamiliar with any of the materials or tools, or if you need to know where to find them, please refer to the Resources Index on page 68.

Watercolors

Equipment and materials needed
- Sheet of glass that is 1/4" thick and at least 12" by 12"
- Glass muller
- Metal scraper or putty knife with a 1-2 inch blade
- Dry or wet pigment – about 2 tablespoons
- Gum Arabic
- Honey (the lighter in color the better)
- Plastic pill containers to hold strips of watercolor cakes

Directions

Place pigment in center of glass sheet. If it is dry, add enough distilled water to make a thick paste. Shape into a mound with the metal scraper, and dig a well in the center. Using the size of the mound as a guide, add one fourth its volume of gum Arabic into the well and half the gum Arabic's volume in honey. The solution is now 8 parts wet pigment to 2 parts gum Arabic to 1 part honey. Using the glass muller, mix all the ingredients together in a circular motion, remembering to clean off the edges of the muller periodically and re-mix the solution. Scrape the resulting watercolor into the sectioned pill box. Leave the lid open for a few days so the watercolor can harden. Often these watercolor cakes will dry with cracks or even dry away from the sides of their container. I have not found this to be a problem when using them; simply dampen the surface and paint as you would with commercial pans of watercolors.

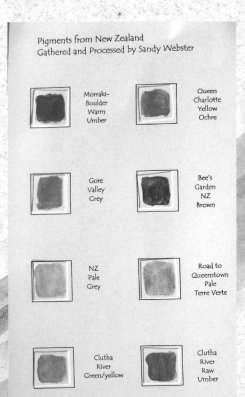

Pigments from New Zealand
Gathered and Processed by Sandy Webster

Morraki-Boulder Warm Umber

Queen Charlotte Yellow Ochre

Gore Valley Grey

Bee's Garden NZ Brown

NZ Pale Grey

Road to Queenstown Pale Terre Verte

Clutha River Green/yellow

Clutha River Raw Umber

Before cleaning my tools, I will paint a small swatch sample with some of the residual pigmented watercolor and label it with the name I have given this color. These samples can be cut and pasted onto a larger sheet with their names and kept with the strip of watercolors for reference.

Gouache Cakes

Equipment and materials needed
- Sheet of 1/4" thick glass at least 12" by 12"
- Glass muller
- Metal scraper or putty knife with a 1-2" blade
- Dry pigment, about 2 tablespoons
- Calcium carbonate or French chalk
- Gum Arabic
- Honey
- Small airtight containers to store gouache cakes

Directions

Add one part calcium carbonate or French chalk to six parts dry pigment and mix thoroughly. As in the watercolor directions, make a mound with an indentation along the top. Add enough distilled water to make a thick paste. Add gum Arabic in a proportion of one part gum Arabic to four parts pigment paste solution. Add one half that amount (gum Arabic) of honey to the solution. The proportions are now eight parts pigment/calcium carbonate to two parts gum Arabic to one part honey. Mull it all together using a muller or putty knife. Place in airtight container or use immediately.

Egg Tempera

Equipment and materials needed

- One fresh egg yolk
- Wet pigment
- Distilled water
- Small water tight container
- Palette with air tight plastic cover (egg temperas dry very quickly once they are mixed)

Directions

If your pigment is in a dry form, mix in enough distilled water to make a paste the consistency of sour cream. Place the paste into a waterproof and airtight container, and cover with additional distilled water. The wet pigment will fall to the bottom and stay moist.

First, prepare the egg yolk emulsion by discarding the white of the raw egg, gently rolling the yolk on a hammock of paper hand towel, then when the yolk is clean of all egg white, lift it by its skin and pierce the skin with a pin. Squeeze the yolk's inner liquid into a water tight container (a plastic film canister works well). Discard the skin of the yolk. To the saved yolk add the same amount by volume of distilled water and shake thoroughly. This solution will keep up to three days in the refrigerator.

When you are ready to mix up the egg tempera paints, remove a very small amount of wet pigment paste by dipping below the water in the pigment container. It should be no more than the size of a lentil bean. Mix this with an equal part of the egg yolk solution in the wells of a palette and use it before it hardens. Mix all the colors in the same manner. You can keep them in a sealed palette in the refrigerator between uses for not more than a day. Then you will need to clean it and mix new egg tempera paints.

A note on egg tempera painting:
It must be done on a rigid support that has been coated in the traditional way by using many layers of a gesso made from scratch and many, many layers of built up color. There is nothing that will match the radiance of an image painted using traditional egg tempera methods.

Glair

Glair is a binder made from egg whites that was traditionally used in painting illuminated manuscripts. By itself it adds a smooth satin finish over gouache paintings and prevents smudging. This recipe is how I have used it as a binder with my natural pigments.

Equipment and materials needed

- Small ceramic or stainless steel bowl
- Hand cranked beaters (an electric mixer can also be used)
 - One to two eggs
- Small dark bottles for storage
- Eye dropper
- Distilled water

Directions

Gently break eggs over the bowl to remove only the whites. Discard the yolks and shells. Beat the whites into a froth that is like a meringue in consistency. Let sit at room temperature several hours or overnight. Then gently remove all the foam from the top. The liquid that remains is the glair. Pour into dark bottles to store in refrigerator until needed. The eye dropper aids in getting the small amount of glair necessary to mix with the pigments before painting.

When working on small illustrations I use a mixture of one part wet pigment to one part glair, and thin if needed with distilled water.

Casein or Milk Paint

The thickness of milk paint can vary from a thin wash to a heavier cream-like consistency.

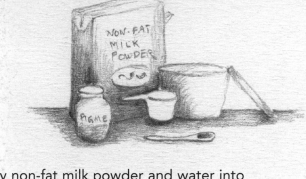

Equipment and materials needed
• Non-fat milk powder
• Water
• Dry or wet pigments
• Measuring cups
• Plastic containers for mixing and storing

Directions
Begin by measuring equal portions of dry non-fat milk powder and water into a plastic container. Stir in desired amount of dry or wet pigment. This paint can be thinned with water and used as you would watercolors and gouache.

Note: This medium has a relatively short life before mold sets in, so only mix up as much as you intend to use at one time.

Casein and Wheat-Based Modeling Paste

I learned the basics of this method from Trace Willans of Tasmania and adapted it to the materials and equipment in my own studio. It is best to mix up only what can be used in a short period of time. It may require thinning with water if it begins to thicken too much to use easily.

Equipment and materials needed
- Electric hotplate or stove top
- Saucepan
- Whisk
- Rubber spatula
- Measuring cups
- Plastic containers for mixing
- Cake flour such as Swans Down or Soft as Silk (Rice flour may be substituted)
- Non-fat milk powder
- Water
- Dry pigments
- Palette knife
- Plastic squeeze bottles (optional)

Directions

First prepare a wheat paste by placing five parts cold water to one part cake flour in a saucepan, and continue whisking over medium heat until it begins to thicken and come to a boil. The paste will look translucent and send "blurping" bubbles to the surface. Remove from heat and let cool. This paste is good to use for about three days if kept in the refrigerator.

Make a skim milk or casein paste by combining two parts skim milk powder to one part water. Mix thoroughly. Thin the mixture with water until it is about the same consistency as the wheat paste. Now thoroughly mix one part wheat paste to one part casein mixture. At this point you can mix in pigments and use as desired. This will be a thick paste that should only be used on heavy supports such as rigid boards or thick watercolor papers. Applications can be done with palette knife or by putting the mixture into small squeeze bottles with openings to squeeze out heavy lines and marks. Once the work is finished and completely dry, it will be very hard. Experiment with different colored layers of modeling paste. I use an electric hand sander to expose the different layers. Rub the finished work with a cold wax (recipe follows) that can be clear or with pigment added. This seals the work and can be buffed to a satin finish when the wax has dried completely.

Cold Wax Medium

I use this cold wax over textured surfaces to give a soft additional translucent color. After my work has completely dried, the following day I buff it with a soft cotton rag, giving it a lovely feel and finish.

This recipe should be made in an area with good ventilation and very low heat. Wax and turpentine are highly flammable.

Equipment and materials needed
- Electric hotplate
- Small disposable aluminum foil bread baking pan
- Hot pads for holding hot pans
- Beeswax
- Turpentine
- Dry pigment
- Palette knife
- Small glass or plexiglass sheet for mixing pigment and turpentine
- Jars for storing

Directions

Melt one half cup beeswax in an aluminum pan over low heat. Remove from the hotplate when it is still liquid and warm. Add an equal amount of turpentine to the mixture and stir together carefully to avoid splashing onto the hotplate. Quickly make a paste using small amounts of dry pigment with an equal part of turpentine, and stir this into the wax mixture. If the wax is too hard to thoroughly mix with the added pigment solution, carefully place the pan over the warm hotplate to soften. More pigment and turpentine mixture can be added to intensify the color. When the wax is evenly colored, pour it into jars, cool and fix lids in place. Heat and wipe out the aluminum pan and begin again with another color of pigment. It is not necessary to add pigment if you want to simply make a jar of clear paste wax.

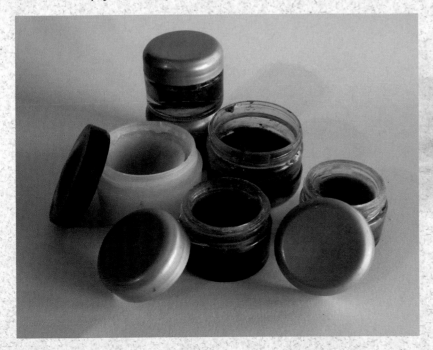

I recycle small cosmetics jars for storing these pigmented paste waxes.

Wax Crayons

Equipment and materials needed
- Electric hotplate
- Small aluminum loaf pan
- Hot pad
- Palette knife
- Sheet of glass or plexiglass about 12" square
- Heavy duty aluminum foil
- Metal spatula
- Beeswax – one pound
- Paraffin – a one pound box of four bricks
- Boiled linseed oil
- Dry pigment

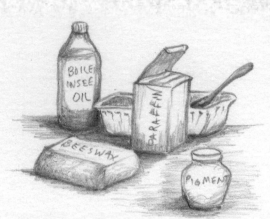

Directions
Place a chunk of beeswax in a pan and slowly melt it over low heat on the hotplate. As the wax starts to melt, add the same amount of paraffin as beeswax and stir. Onto the glass sheet mix one tablespoon of dry pigment with one tablespoon of boiled linseed oil with a palette knife. Add the pigment and oil to the wax and mix thoroughly. Shape a piece of aluminum foil into a shallow pan form that is close in size to the bottom of the loaf pan with one inch high sides. Press corners tightly to prevent leaks. While the wax-paraffin mixture is still liquid, pour it into the shaped pan and let cool until it is just setting up. Take a metal spatula and cut the wax into several crayons. When almost completely set up, take the foil away and rub the crayons in your hands to shape further. If the crayons need more color, melt them down again and add more pigment to the solution. Then pour it back into another shaped foil pan and cut as before.

Note: A variation of this recipe which yields a drier, less-oily wax crayon is to eliminate the boiled linseed oil and just add dry pigment directly to the waxes. Be sure to mix thoroughly and continue mixing until you pour the crayons, as the pigment will drop to the bottom of the pan.

Pastel Crayons

Equipment and materials needed
• Glass or plexiglass sheet at least 12" square
• Palette knife
• Dust mask
• Rubber gloves
• Dry pigment
• Distilled water
• Calcium carbonate
• Talc
• Bar of white soap such as Ivory

Directions

Put on mask and gloves. Make a mixture of one part talc to three parts calcium carbonate and set aside. Place about one tablespoon of dry pigment on the glass sheet. Make a well in the top and fill with just enough distilled water to make a thick paste. Mix in a few shavings of white soap which will aid in the binding and smoothness of application. Now add enough of the talc and calcium carbonate mixture to make a very stiff paste that can be rolled and shaped into a crayon. Shape the pastel crayons quickly. Too much rolling can push the ingredients apart and create a seal of the binders on the outside layer of the crayons and inhibit mark making. If there is not enough intensity of color more pigment can be added to the pastel after it has been broken down to a powder form. Simply add the pigment and enough water to shape into the crayon. Flatten the ends and set aside. When you have finished making all the pastels you want, let them dry for several days until they are completely hard all the way through.

Fabric Paints

I have a collection of bogolanfini (mud cloth) from Mali in Africa (see page 49). The density of color and intricate designs on the cloth are achieved using a bath of tannic acid from the leaves of the Bogolan tree and iron rich mud that has become increasingly darker by fermenting in vats for up to one year. These solutions are put on hand-woven cotton strips that have been stitched together to make panels of cloth to be colored and used for ceremonial purposes and special occasions.

My experience in using earth pigments on cloth is limited to cotton, on small 12 to 18 inch squares. These sizes are easy to handle and can be cut and torn into smaller pieces for collage and pieced work. Be sure to wash new fabric first to remove any sizing that may have been added. Like the bogolanfini cloth, a tannin solution is necessary to set the colors when using cotton. The simplest way to make this setting solution is to use four large tea bags in eight to ten cups of boiling water and steep the swatches for twenty minutes. This will color the fabric to a light tan, but it helps fix the pigment colors that are painted on top.

Equipment and materials needed
- Electric hotplate
- Empty plastic food containers
- Large saucepan
- 4 large black tea bags
- Large plastic sheet
- Stainless steel spoons
- Inexpensive brushes from 1/2 inch to two inches
- Dust mask
- Small plastic containers for mixing
- Soy milk (commercially available is acceptable)
- Medium sized bowl
- 2" foam brush
- Dry pigments

Besides using this soy milk and pigment emulsion on cloth, I have tried simply brushing it onto large sheets of paper and making small watercolor marks that result in a smooth translucent wash much like pigments with a glair binder.

Directions

While the fabric pieces are steeping in the tannin solution (see previous page), put on your dust mask and in the plastic containers prepare a pigment/soymilk emulsion. Combine one part dry pigment to three parts soy milk. Set the emulsion aside, but stir it at regular intervals while the soy milk is absorbing the pigment.

Place a large plastic sheet on a flat work space and press the wet cloth squares flat to the surface. Next brush the damp cloth with just the soy milk. You can wait for this to dry before brushing on the emulsion of pigment and soy milk, or begin painting as soon as the cloth has been coated with soy milk. Once the first layer of color is brushed on, let the cloth completely dry. Additional layers of the emulsion will intensify the color but it must dry thoroughly between each layer. Leave the cloth on the plastic to absorb all the pigment particles from the plastic below. (This process is called "batching.") When the fabric and plastic have completely dried, move the cloth to a place where it can be left to rest. Leave the cloth as long as possible before rinsing. This insures greater stability of the color.

Note: Australian textile artist, Philomena Hali, makes patterns on her cloth with a thick solution of intensely pigmented Northern Territory ochre and water. She then leaves it to dry outside in the sun. After a few days, she rinses out the brightly colored cloth. See page 48.

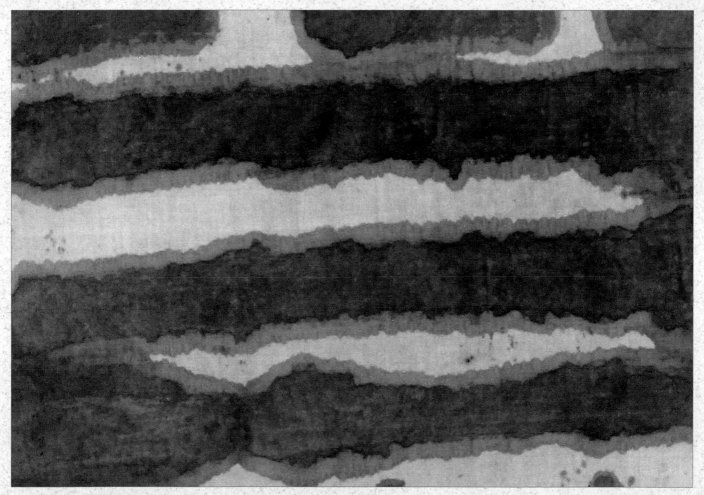

Detail. Philomena Hali. Cotton textile colored with native "mud" of the Northern Territory, Australia: 18" x 60".

Printmaking Ink

Making a good quality relief printing ink from hand-gathered pigments is not easy to accomplish. I select only my finest ground pigment powders and will still get a slightly gritty ink. The deeper colors are good for use in inking the block's image, while lighter pigments can make an interesting background color to the wood block. For a black ink, I use pigments made with charcoal from firing pits or scrapings from blacksmith vents. Making relief inks from your pigment collection is definitely worth pursuing if you are a printmaker and would like to experiment with marking "place" onto your prints. Examples of my own relief and monoprints using natural pigments can be seen on pages 24, 39, 54, and 55. There is also an extraordinary natural pigment relief print by Australian aboriginal artist Ros Langford on page 45.

Equipment and Materials needed
- Glass sheet
- Glass muller
- Metal scraper
- Rubber brayer
- Barren or wooden spoon for transferring ink to paper
- Printmaking paper, e.g. Stonehenge, Rives BFK, Arches 88, Japanese papers
- Dry pigment
- Transparent base (found at printmaking supply stores)
- Plate oil or boiled linseed oil
- Plexiglass or glass sheet for making monotypes and monoprints
- Carved linoleum or wood blocks

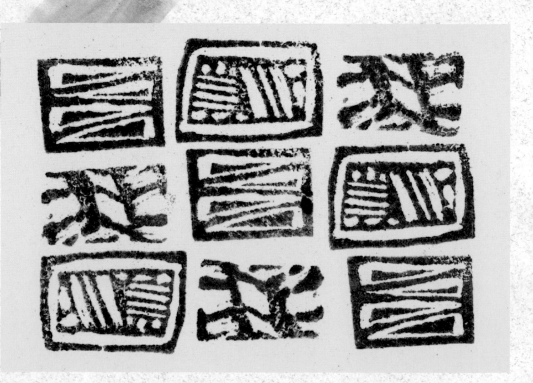

Directions

There are no exact proportions to this process. When mixing an ink, make sure that there is enough to make as many prints as needed. I begin with taking about 1 tablespoon of Transparent Base from the jar with my metal scraper and smearing it down onto the glass sheet. By volume I add twice that much of dry natural pigment and mix them together, first with the metal scraper, then mull them even finer with the glass muller. If it feels too dense to roll the brayer into, I will add just a drop of two of plate oil and continue mixing the ink. *Be careful not to add too much oil, as it will leach through to the other side of the print.* What you want is a densely pigmented ink that adheres to the brayer when rolled through and then, after several rollings in different directions on the glass plate, a slightly tacky whispering sound is heard.

When you think you have the right consistency, try rolling the brayer over your block and see what kind of print it makes. Be careful not to get the ink too thin, as it will ease off the edges of your carved image and make blurry lines. I can usually fix this problem by adding more dry pigment to the already mixed ink and starting over.

For monotypes and monoprints simply roll the ink on a plexiglass or glass sheet and work subtractively by drawing into the ink to remove it. Make your print either by using a press or wooden spoon to transfer the image. When the print is completely dry, try using another pigment colored ink to create layered imagery.

EARTHEN PIGMENTS

7

LAST WORDS

GATHERING AND PROCESSING NATURAL PIGMENTS HAS BEEN more exciting for me than actually using them. It is simply a matter of enthusiasm for the project. Digging them out, tucking them into safe places when they are labeled, bringing them home, and turning them into something usable takes time and is an adventure of sorts. I like all the documentation and the reliving of experiences while handling the soils of someplace in particular. But when it comes to actually using them, they take on a preciousness that can be hard to get past. Just how often am I going to be able to get this color or return to this place again? And what if the work doesn't warrant the use of such a potentially charged medium as my hand-gathered pigments? But once the palette knife or brush or brayer is covered with pigment and the mark making starts these questioning doubts give way to the pure joy of using them.

I will say that most of the work that I do with these pigments tends to be small in size. And only those colors that I have in abundance become the "testing" pigments for different applications. If the gathered soils have a strong connection for me, then I will even save the bits left in the sieves to use for embedding into mediums and create encrustations for book covers or sections of collage works. It is hard to throw some of the collected clays, soils, rocks, and dirt away.

I am continually drawn to exposed colors in the earth and therefore keep the basic supplies for gathering in my car. My studio has a room designated for processing the gathered rocks, soils, and clays into fine powders of color... all sorted, labeled, and loaded with possibilities and memories.

Aside from words, marks made by gathered soils are the perfect way to express a narrative of "place" – both are important considerations in my own art practice. For other artists it can simply be a way of making a usable medium from the extraordinary colors available right in front of us. However you choose to proceed, the time and results will be rewarding. I hope this book has helped you on your way.

—Sandy Webster

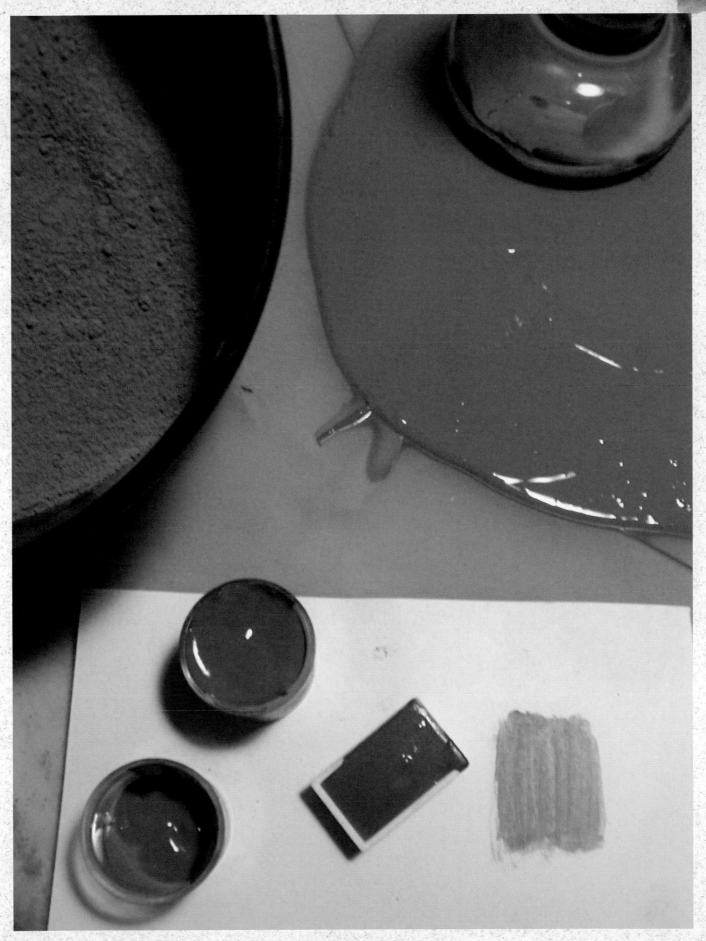

The processing of *Pine River Raw Umber* gathered near where I was born.

8
GALLERY

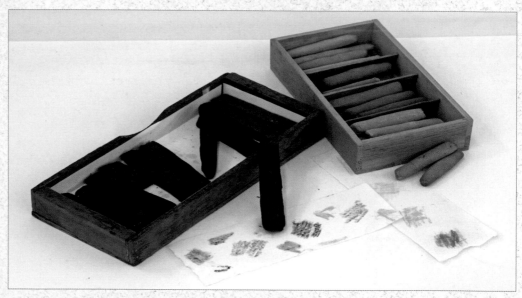

Wax crayons and chalk pastels made by author from local pigments. *Photo by Phil Diehn.*

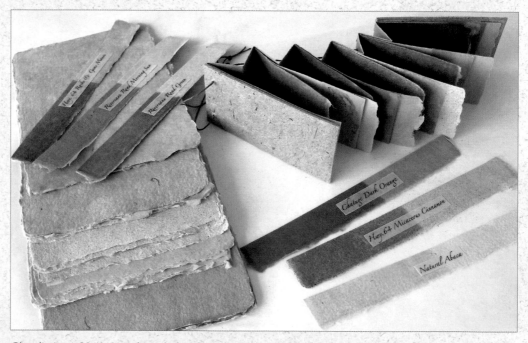

Claudia Lee. 2011. Hand made book and papers made using pigments from author's collection.

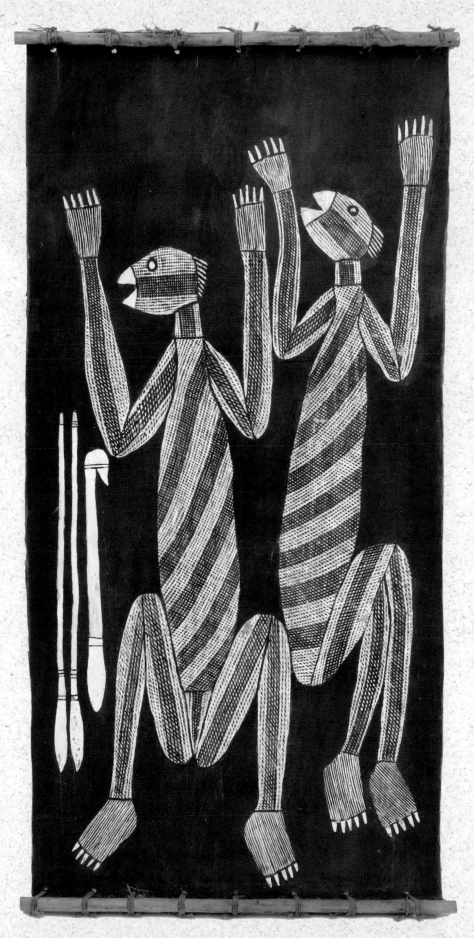

Mimi Carving. Artist Unknown. Wood and natural ochres from Northern Territory, Australia: 2.5" x 30" x 1.5". *Photo by Phil Diehn; collection of the author.*

Mimi Figures. Jimmy Namarnyilk. Bark painting in natural ochres from the Northern Territory, Australia: 20" x 36". *Photo by Phil Diehn; collection of the author.*

EARTHEN PIGMENTS

Jane Henry. Paper and wood structure using natural pigments of Australia to cover the joined areas: 10" x 15".

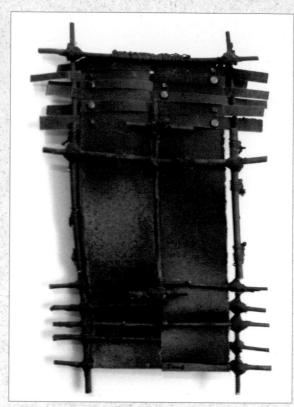

Boxed set of eighty-four watercolors made by author from the gathered ochres of Australia over a period of fourteen years. *Photo by Phil Diehn.*

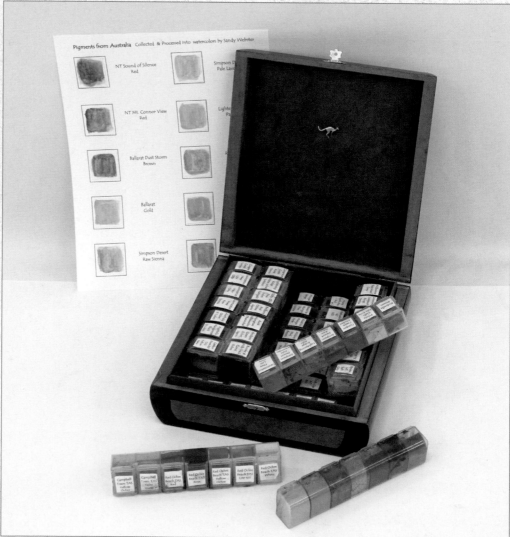

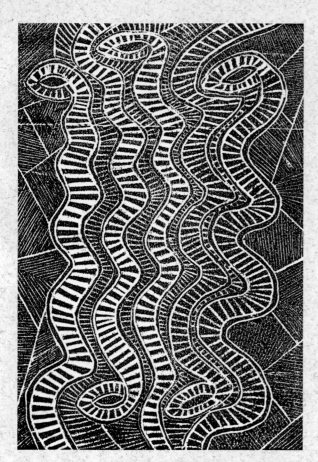

Eel Traps, 1. Ros Langford. Relief print using natural ochres of Tasmania: 20" x 30".

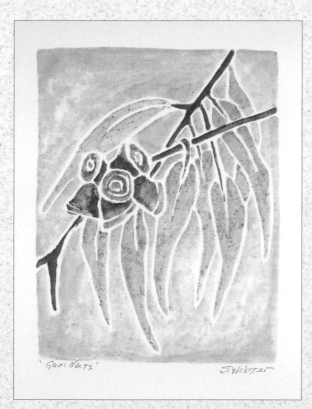

Gum Nuts, 1. Sandy Webster. White Line woodblock print colored with pigments from Australia: 6" x 8".

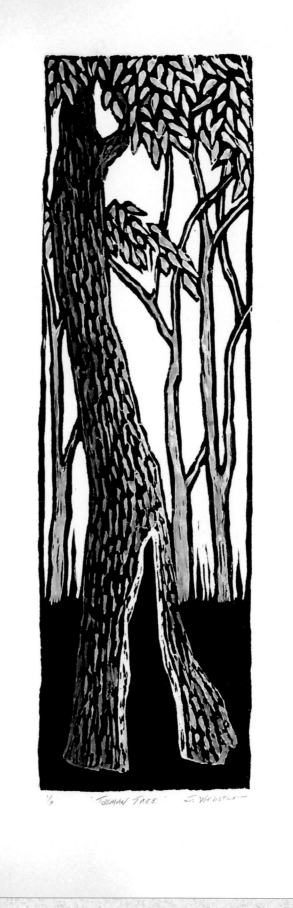

Tasman Tree, 09. Sandy Webster. Relief print colored with watercolors made from ochres of Australia: 4" x 15".

EARTHEN PIGMENTS

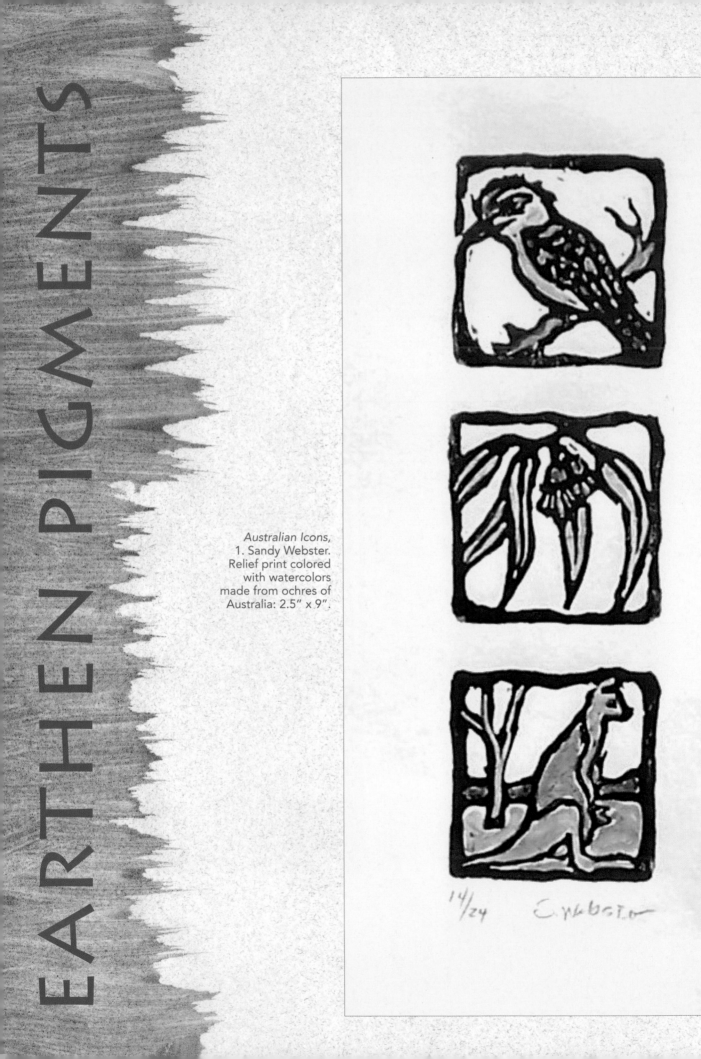

Australian Icons,
1. Sandy Webster.
Relief print colored
with watercolors
made from ochres of
Australia: 2.5" x 9".

14/24 Webster

Turning Point, 08. Sandy Webster. Acrylic, gouache and hand-gathered pigments: 36" x 12". *Photo Phil Diehn.*

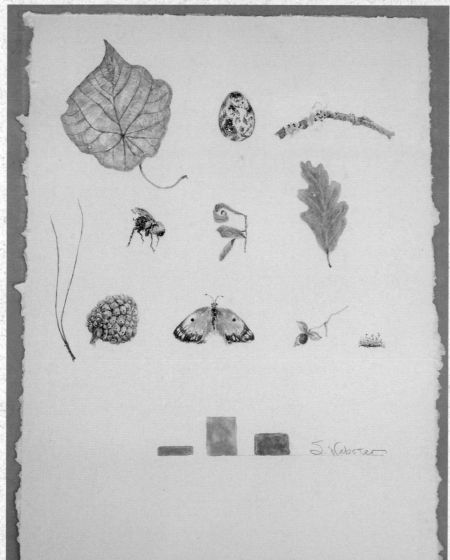

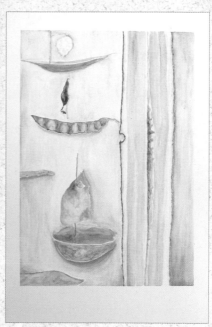

Voyagers Two, 1. Sandy Webster. Watercolor using only natural pigments made in studio: 16" x 22".

Narratives of Nature, 08. Sandy Webster. Watercolor signed by artist and the natural pigments representing where the objects were found: 12" x 14".

EARTHEN PIGMENTS

Kuba skirt panel from Zaire, Africa. Natural pigment on raffia: 20" x 120". *Collection of the author.*

Philomena Hali. Cotton textile colored with native "mud" of the Northern Territory, Australia: 18" x 60".

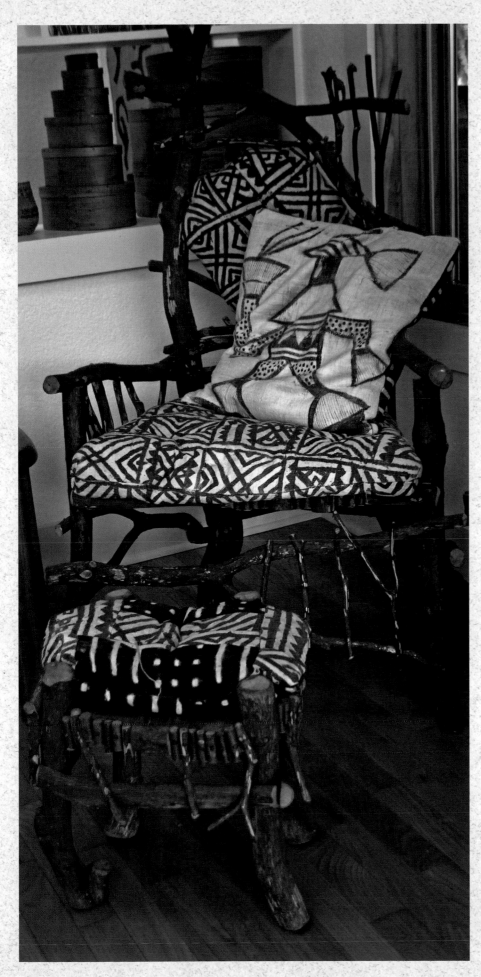

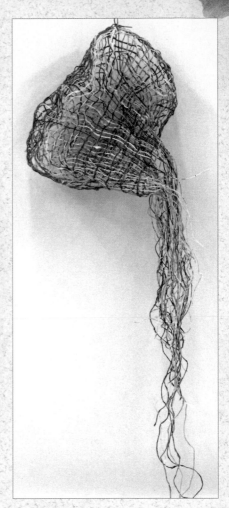

Travel Threads, 1. Sandy Webster.
Shifu woven basket: 10" x 10" x 32".

The African Chair, 94. Sandy
Webster. Bogolanfini (mud cloth)
used in chair made by author: 24"
x 48" x 48" overall measurements
with stool. *Photo by Phil Diehn.*

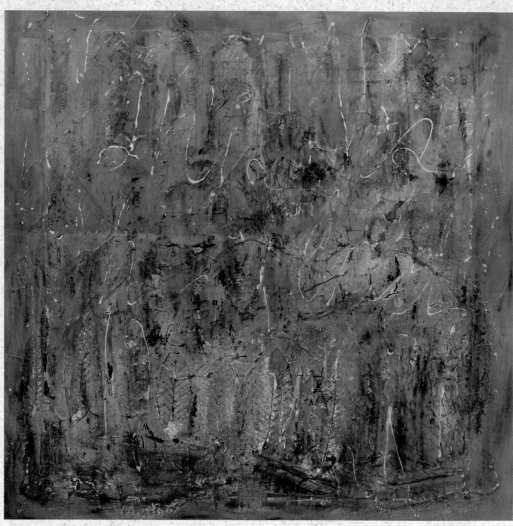

Local Color, 1. Sandy Webster. Mixed media painting using
local pigments mixed with acrylic paint, pigmented wax crayons
over embedded objects: 36" x 36".

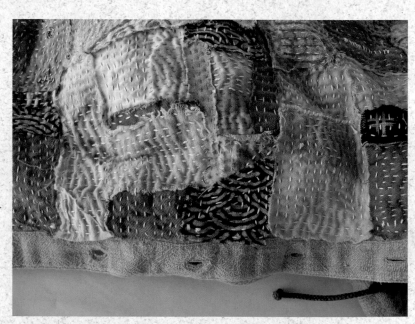

Stitched patches
on a shirt. Some
of which have
been dyed with
hand-gathered
pigments by
the author.

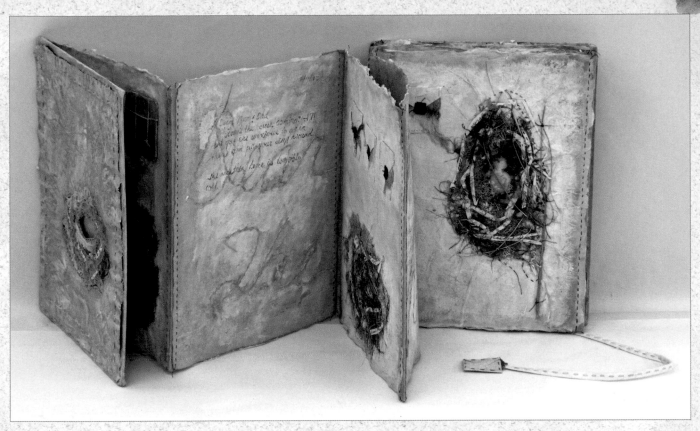

Ties to Home, 1. Sandy Webster. Mixed media using colors of artist's birthplace and home in North Carolina: 9" x 12" x 2" closed, opens to 5'. *Photo by Phil Diehn.*

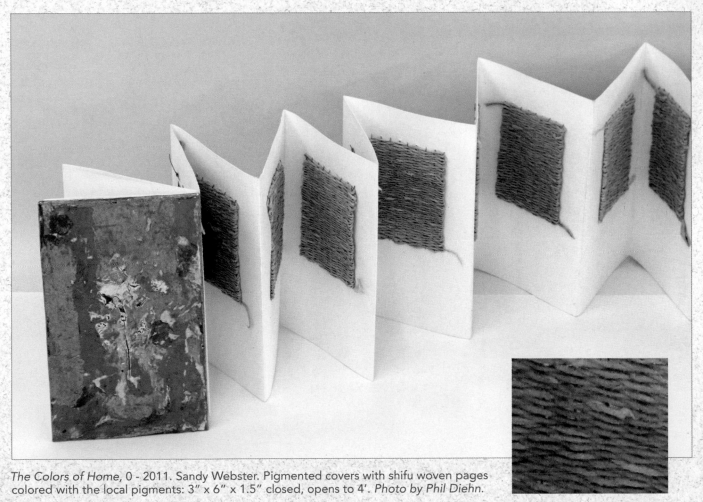

The Colors of Home, 0 - 2011. Sandy Webster. Pigmented covers with shifu woven pages colored with the local pigments: 3" x 6" x 1.5" closed, opens to 4'. *Photo by Phil Diehn.*

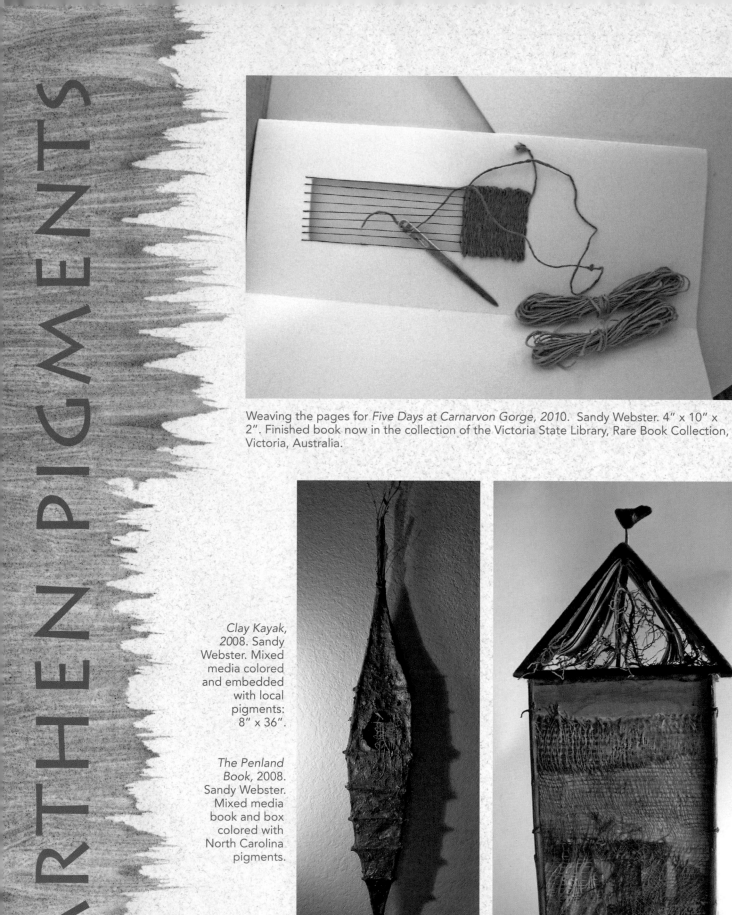

EARTHEN PIGMENTS

Weaving the pages for *Five Days at Carnarvon Gorge, 2010*. Sandy Webster. 4" x 10" x 2". Finished book now in the collection of the Victoria State Library, Rare Book Collection, Victoria, Australia.

Clay Kayak, 2008. Sandy Webster. Mixed media colored and embedded with local pigments: 8" x 36".

The Penland Book, 2008. Sandy Webster. Mixed media book and box colored with North Carolina pigments.

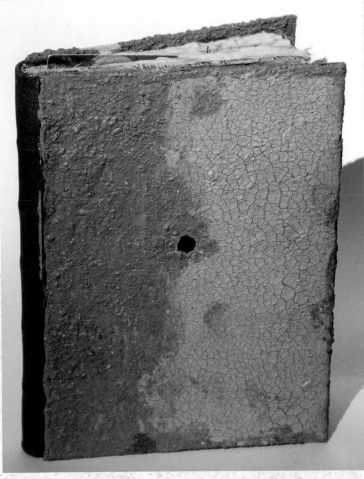

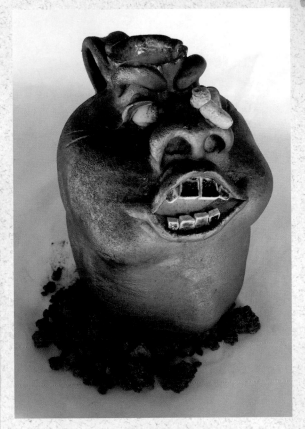

Rob Withrow. 2011. Local pigment used to glaze stoneware face jug that has been fired in a wood-fired kiln.

Vineyard Clay-Covered Journal. Gwen Diehn. Mixed media hand made book: 5.5" x 7.5" x 1". *Photo by Phil Diehn.*

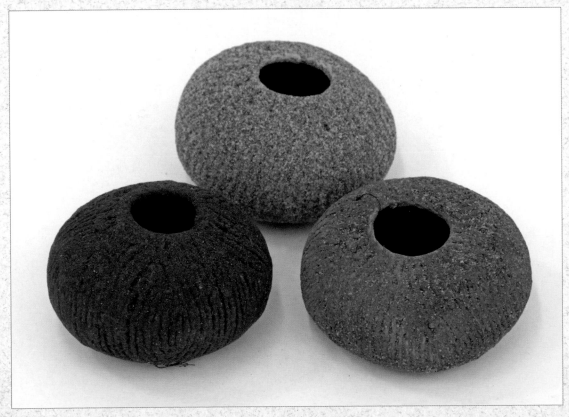

Baskets. Jane Whitten. Knitted basket forms encrusted with the sands of the artist's travels and home of Australia: 3" x 2" x 3" each.

EARTHEN PIGMENTS

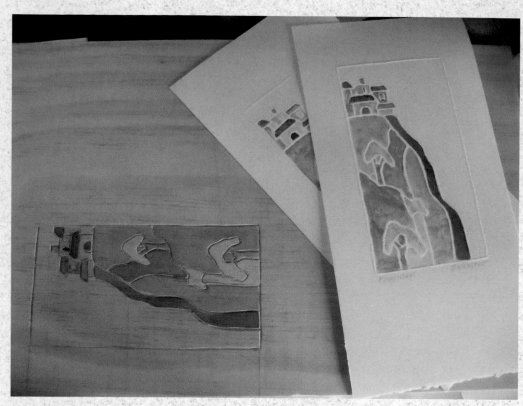

White line printing of *Roussillon on the Ridge* by author. Watercolors made from pigments gathered in France.

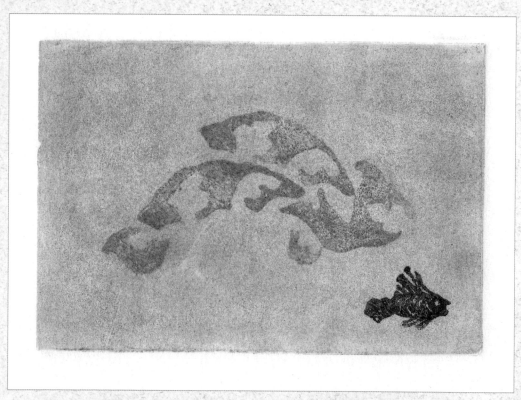

Fish, 1. Sandy Webster. Monoprint and stamping using earth pigments: 6" x 4.5".

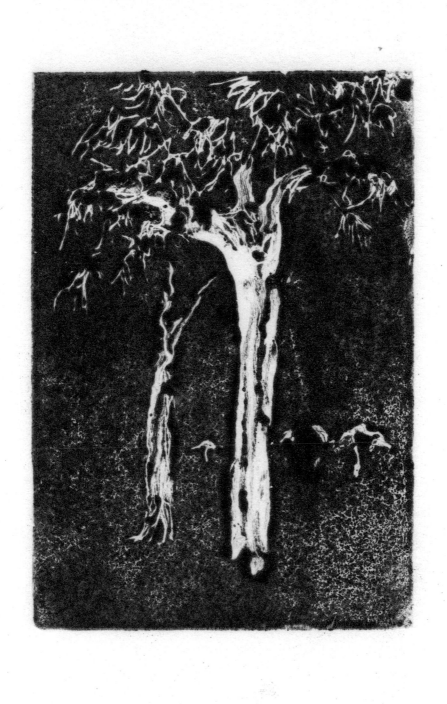

Ghost Gums, 1. Sandy Webster. Monotype made using ink made from hand-gathered pigments: 5" x 7".

EARTHEN PIGMENTS

9

OCHRE SITES WORTH VISITING

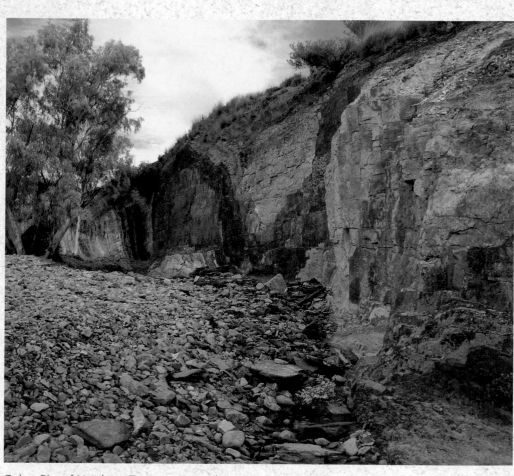

Ochre Pits of Northern Territory, Australia.

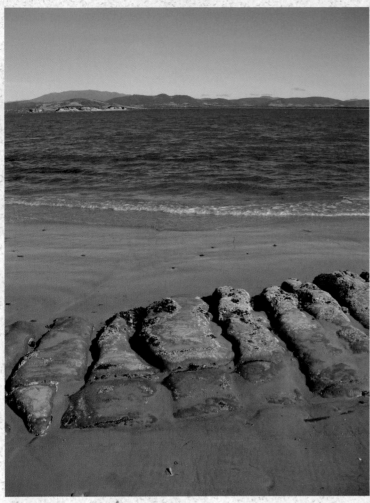

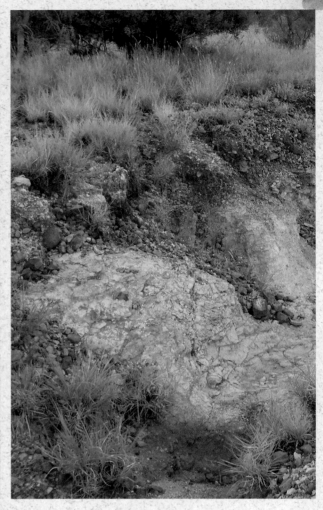

Red Ochre Beach, Tasmania, Australia.

Alice Springs, Northern Territory, Australia.

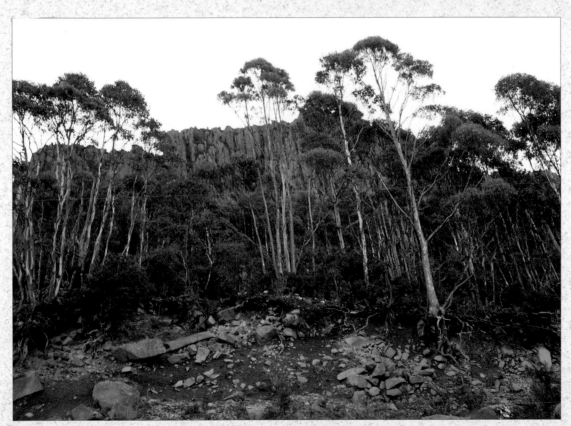

Mt. Wellington, Hobart, Tasmania, Australia.

EARTHEN PIGMENTS

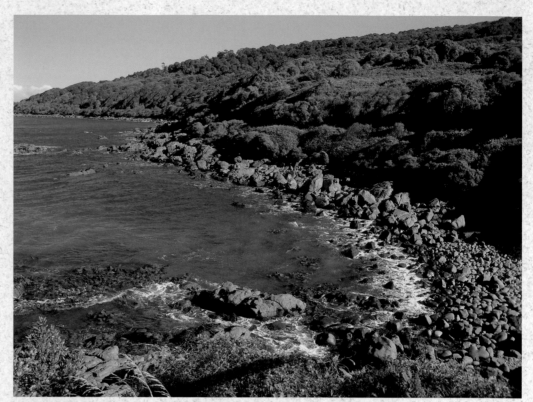

Beaches of the
South Island,
New Zealand.

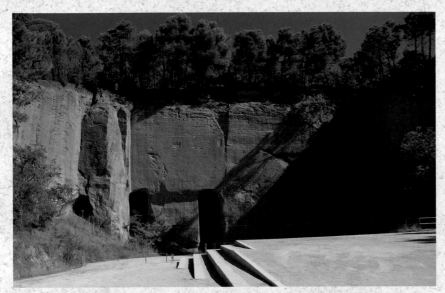

Mines de Broux, Gargas, France.

Ochre cliffs of Roussillon, France.

Opal mine shaft, White Cliffs, Australia.

Colorado Range, Rustrel, France.

EARTHEN PIGMENTS

Sennelier Paint Store,
Paris, France.

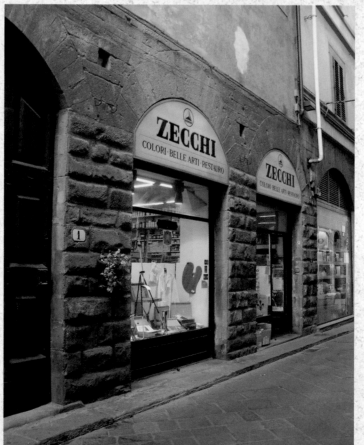

Zecchi's Art Supply,
Florence, Italy.

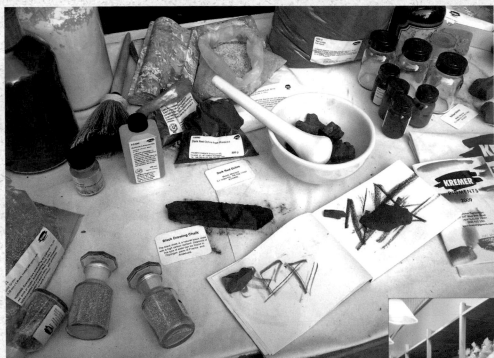

Kremer's Pigments, New
York City, New York.

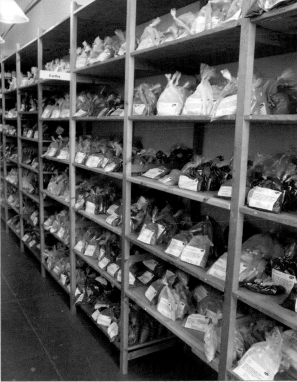

Pigments from your own area.

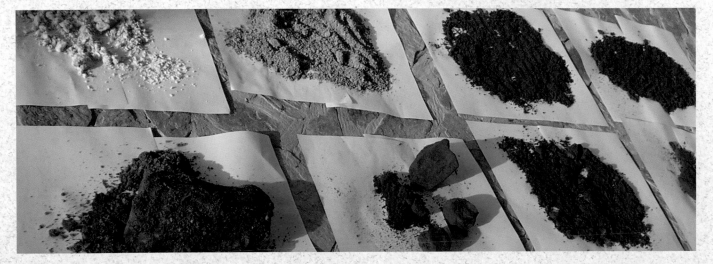

GLOSSARY

batching: saturating with liquid pigments
bogolanfini: patterned mud cloth made in Mali, Africa

calcined: heated to cause loss of moisture
calcium carbonate: mineral, calcite, present in chalk, limestone and marble
casein: protein found in mammalian milk
celadonite: dull green or green blue mineral
Coptic binding: stitched binding in books developed by early Christians in Egypt

denatured alcohol: solvent also know as methylated spirits

encrustation: hard coating on the surface of objects sometimes containing embedded matter

French chalk: a fine white calcium carbonate

gesso: traditionally a white paint made from rabbit skin glue and calcium carbonate
glair: pigment binder made of egg whites
glauconite: mineral that is blue green to yellow green in color
gouache: heavily pigmented water paint that also contains a white powder
gum Arabic: binder made from the hardened sap of the acacia tree

hematite: the mineral form of iron
humectant: substance that promotes the retention and fluidity of water paints

iron oxide: chemical compound of iron and oxygen
iron silicates: iron combined with a silicon such as sand

levigate: filtering with consecutive water baths
limonite: hydrated iron oxide used for gold to brown colored pigments
lokta paper: hand-made paper made in Nepal from a fibrous bark

manganese: chemical that is a silver-grey metal often found with iron
monoprints: type of prints made using paints and inks on the cleaned surface of a plate
monotypes: prints made by drawing marks and removing ink from an ink or paint covered plate

ochre: earth pigment
organic matter: remaining product of a once living organism

shifu: woven cloth from spun paper threads. Originally practiced in Japan.

tannic acid: organic acid found in most plants
terre verte: green earth pigment
transparent base: colorless extender used for mixing with relief inks

white line prints: wood block prints colored by using watercolors between carved white lines instead of inks. Also known as Provincetown prints.